HAUNTED BY THE LIVING
FED BY THE DEAD

Giorgia Pavlidou

Introduction by John Olson
Author of Weave of the Dream King

HAUNTED BY THE LIVING
FED BY THE DEAD

By Giorgia Pavlidou

Copyright © Giorgia Pavlidou 2022

The right of Giorgia Pavlidou to be identified as the author of this work has been asserted in accordance with the Copyright, Designs and Patents Act, 1988.

All rights reserved. No part of this book may be reproduced or transmitted in any form or by any means, other than that in which it was purchased, without the written permission of the author.

ISBN 978-0-578-38448-1

Names, characters, businesses, places, events and incidents are either the products of the author's imagination or used in a fictitious manner. Any resemblance to actual persons, living or dead, or actual events is purely coincidental.

Cover art by Giorgia Pavlidou "Stillbirth" 4'2' acrylic on wood panel
Formatting by Ryan Ashcroft

Anvil Tongue Books

Τούτ' η γης, κυρά Γιώργαινα,*
τούτ' η γης που την πατούμε,
ούλοι μέσα θε να μπούμε,
Τούτ' η γη με τα χορτάρια,
τρώει νιους και παλικάρια.

Τούτ η γης με τα λουλούδια,
τρώει νιους και κοπελλούδια.
Τάχα θε να φάει και μένα
με τα φρύδια τα γραμμένα

*Old Greek Folk song similar to Ralph Stanley's O Death, κυρά Γιώργαινα: Lady Death

"Being dead means very light housekeeping."

- Roger Gilbert-Lecomte

"At its roots, poetry is a haunted practice, calling to the dead, crossing boundaries again and again. Its power can seize the invisible and give it purchase in our world."

-Peter Gizzi,

from the preface to the 2021 edition of Jack Spicer's *After Lorca*

For the grandfather I can't remember yet whose stories have decisively impacted my life, and my father-in-law who died before I married his son. Uncannily, both are guiding me through the spider webs of the future.

Introduction: No Better Way To Know Death .. 11
disfigured 16
grandpa's frozen birds 18
Truth-Poor................................. 20
ground hummingbirds 24
of the dead i hold dear 28
The sound of one short sentence can kill 32
undertaker of the mind 34
Love? 36
lingual interloper 38
ouR abandoneD senilE fieldS 40
Husband became my ex-wife 42
soft typewriter of the womb 44
the black city 46
a necromancer's advice to baudelaire 50
artifacts for future space travel................ 52
electroshock therapy for the climate 54
the invisible men of mist 60
Where's my lizard?......................... 64
you loved me once after i died *70*
the one true body.......................... 72
foreigner................................... 76

Most of these poems and paintings have appeared in journals or print collections such as Strukturriss, Maintenant Dada Journal, Unlikely Stories, Witchcraft Journal, Ceasura, Entropy, The Room, Anvil Tongue, Zoetic press, Thrice Fiction and SULΦUR.

Introduction: No Better Way To Know Death

There are 109 chemicals in the human body, including 42 mystery chemicals. Some of these include some really good stuff, like dopamine, oxytocin, serotonin, and assorted endorphins. Almost 99% of the mass of the human body is made up of six elements – oxygen, carbon, hydrogen, nitrogen, calcium and phosphorous – and only about 0.85% is composed of another five elements: potassium, sulfur, sodium, chlorine, and magnesium.

Poet and artist Giorgia Pavlidou would add another to the mix: language. Language isn't a chemical, but it could be. It could also be – as William Burroughs famously pointed out – a virus. Whatever language is and however it may function in human consciousness, it has an enormous influence on mood, attitude, perspective, motivation and overall *weltanschauung*. It can torture, it can elevate, it can expand and it can narrow. It's a driver of the actions we take, the food we eat, the demons we summon, the angles we invoke, the people we desire and a chief component of desire itself. "The limits of language," said Wittgenstein, "are the limits of my world."

Pavlidou takes a Lacanian point of view. Language is a living, breathing entity, a force independent of any human subject. Our perception of language as a tool belies the more fundamental action of language as an autonomous element guiding our behavior and perceptions in ways that favor its propagation. The relation is importantly symbiotic: as language evolves our input in terms of new expressions, vocabulary, intonations and syntax nourish the organism in a collaborative dynamic of consanguinity. Lacan refers to language as an Other, an agency acting independently, outside of our control. When we're writing and talking we have the quite natural feeling that we're speaking our minds, finding expression for an inner subjectivity we deludedly believe is a domain entirely within our control. Anyone familiar with the iniquities of propaganda knows this is patently false. Language can very insidiously modulate our opinions and shape our perceptions and impact our judgment. This is what poets are constantly fighting against. As I write this, for example, I have to wonder: how much of this is me and how much of this is the result of predigested

literary theory and political orientation? This is a crucial awareness and is where I find a strong sympathetic cord to Pavlidou's struggles to push back against the controlling energies of language and find a deeper, more essential language for the expression of soul and the exquisite trauma of liberation.

An important consequence of Lacanian theory is – given language's autonomy – a strictly referential approach in which words enjoy a one-to-one relation with the phenomena in external reality and correspondences to our internal states is rendered immaterial. This has a powerful impact on what we call truth, what we call objective reality. They don't exist. "Is language the adequate expression of all realities," asks Nietzsche, and the answer of course is no. No way can this abstract machine we use to fly around in our heads in any way equipped to fully represent, completely express, from top to bottom, the immensity of the universe and the fullness of existence. Nietzsche has an answer for this:

"What then is truth? A movable host of metaphors, and anthropomorphisms: in short, a sum of human relations which have been poetically and rhetorically intensified, transferred, and embellished, and which, after long usage, seem to a people to be fixed, canonical, and binding. Truths are illusions which we have forgotten are illusions – they are metaphors that have become worn out and have been drained of sensuous force, coins which have lost their embossing and are now considered as metal and no longer as coins."

Introduce human sexuality into the mix and things really start to get messy. Pavlidou's poetry is a fire that destroys as it heats and gives us light. It is both sensuous and colorful according to Pound's identification of *phanopoeia*, "a casting of images upon the visual imagination," and *logopoeia*, the usage of words in some special relation to context, the conveyance of ideas, the strategies one employs to heat and provoke the mind of the reader, or audience.

There's an *agon* at the center of Pavlidou's poetry, a conflictual energy embodied in the blood and bones of her language, in the air ripped apart to reveal the incandescence at the heart of everything. Lines abound in a violence that is fiercely libidinal, an anguished and darkly Gothic

sexuality heated by the very language used to embellish its savage impulses and give a deathly pallor to its macabre beauty :

"The sound of one short sentence can kill," "undertaker of the mind," "skyscrapers in my head explode," "a sign for you / to drag my enormous corpse / over sleeping cobblestones," "it drills and drill and drills. i'm pierced to the bed as if i'm not part of what's happening," "the weight of my words broke its neck," "When Husband lasered his beard away he symbolically lasered his penis away," "picture them as sparkling little lice / wriggling across god's black silicone skin," "exit your corpse / eat up your organs / massage your coffin," "commit suicide in the desert of love," "twist and shout with necrophiliacs in a swirling vulva," "& make love to edgar allan poe / like a beautiful dead woman."

This conflation of erotica with death is not entirely new: one is reminded of works such as *Venus in Furs*, a novella by the Austrian author Leopold von Sacher-Masoch and its musical interpretation by the Velvet Underground in 1967, stories by Edgar Allan Poe such as *Ligeia* or *Fall of the House of Usher*, and most certainly the fiery, phantasmagoric violence running throughout *Les Chants de Maldoror* by the Comte de Lautréamont. French writer Georges Bataille made it the subject of a major work, *Erotism: Death and Sensuality*, in which it is stated that:

"The human spirit is prey to the most astounding impulses. Man goes constantly in fear of himself. His erotic urges terrify him. The saint turns from the voluptuary in alarm; she does not know that his unacknowledgeable passions and her own are really one…Eroticism, it may be said, is assenting to life up to the point of death…although erotic activity is in the first place an exuberance of life, the object of this psychological quest, independent as I say of any concern to reproduce life, is not alien to death."

And then there's the Marquis de Sade: "There is no better way to know death than to link it with some licentious image."
All this thus far is background: the traces and signs of an evolution still in the making, still embroiled in a gestation of linguistic unrest. Echoes in a cavern. Marks on a slab of Peloponnesian stone. This is the well, the spring, the water carried up from a creek, startlingly cold on the lips, a rush

of frost and air down the throat. Poetry is laced with contradiction. It's never a stable mass. It writhes, agitates, convulses and pumps, unexpectedly coils into diamonds and scales, tongue flickering into afternoon heat. The Pythoness of the cave at Delphi opening her eyes, awakened by the sensual exhilaration of prophecy rising from a crevice in the rock, wisps of chthonic vapor sulfurous and piquant, she leans over the abyss, inhales it deeply, and releases vision after vision after vision.

Who doesn't carry a burden of conflict? Who doesn't crave the liberation of trance?

Pavlidou devotes a poem ("Of The Dead I Hold Dear") to another totemic spirit of this collection, Dutch-American painter Willem De Kooning. She begins with a De Kooning quote that reveals another aspect of this work, which is its oneiric, necromantic allure:

> "I'm in my element when I am a little bit out of this world: then I'm in the real world – I'm on the beam. Because when I'm failing, I'm doing all right; when I'm slipping, I say, hey, this is interesting! It's when I'm standing upright that bothers me: I'm not doing so good; I'm stiff. As a matter of fact, I'm really slipping, most of the time, into that glimpse. I'm like a slipping glimpser."

I love this statement. It speaks so directly to that sublime moment of creative transcendence, that beautiful ascendance into an elsewhere that offers so much redemptive energy and armor in dealing with the drearier realities of empirical existence. It doesn't eschew daily life and exchange it with symbolist yearnings. It commingles these values, slathers them on in a thick gooey paint that – in the hands of a painter such as De Kooning – become energized in a palpable muscularity that is so fully apparent on the rough surface of the canvas that its immediacy and physicality is impossible to ignore.

There is a stylistic continuity evident in the paintings Pavlidou has included in this volume. Like De Kooning, the female forms in this series of paintings have a carnal sexuality, an orgiastic frenzy dramatized by the dynamic angularity and sheer boldness of the forms. The colors are vibrant, dissonant, audacious. They clash and churn and storm around one another

in energetic swirls, a turbulent *jouissance*. There is a sense of release and a sense of frustrated containment. The forms are boldly libidinal but also preternatural; they seem like visitors from another dimension, totemic spirits or angels of chaos. They seem like sensual ambassadors from the unconscious, calling to us in a visual display of explosive, earthy liberation.

The two-stanza Greek epigraph at the beginning of this volume is a Greek folk song. It translates roughly as:

> this earth (or soil), o lady death
> this earth on which we walk
> in which we all will end up (in)
> this earth with its grasses
> (she) eats up spirits and lads
>
> this earth with its flowers
> (she) eats up spirits and lasses
> thought she'll also eat me
> (she) (lady death = the earth)
> (she) with her thinly drawn eyebrows

Pavlidou writes: the folksong suggests that lady death is the earth's wife = kyra Georgena, or the earth's representative. The cyclical nature of life and death is not a great mystery; we see it all the time. Here's how I discovered it: one day in late autumn I raked a mass of poplar leaves into a big pile and let it sit for about a week. I saw a wisp of steam and, curious, stuck my hand in the pile and felt a tremendous heat. This was the energy of death. Death conferring life. Life conferring death. I'm not even sure they're opposites. I see them as a fusion. I see them as lovers, limbs entwined in a fluid embrace of lingual *jouissance* as expressed in "haunted by the living - fed by the dead."

-John Olson, author of *Weave of the Dream King*. Seattle, December 2021

disfigured

though i was walking as fast as i could, the hospital hallway seemed endless. my best friend had just become a father. while running, i sensed i was dreaming and i knew i'd see my oldest friend for the first time. i also understood once i'd wake up, i'd never see him again: this friend did not exist in physical reality. when i had finally reached him, his face looked joyous and proud, holding his newborn baby up in the air. when he passed the infant to me, it gradually became clear that its head and face were horrifically deformed. observing its massively disfigured face and skull, i expected to wake up. to my shock, the baby gently snuggled against my chest. with a never felt before sense of exhilaration, warmth and love, i looked my oldest friend in the eyes and said, this baby is absolutely gorgeous. i could feel it in my bones that i truly meant it. perhaps that's why for the days afterwards, i was haunted by the thought that it should have been him to dream this dream and not me.

cyborg spider weaves human infant (acrylic on 4'2' wood panel)

grandpa's frozen birds

small quantities of dream are lodged in the head. we know this because burning birds fly through the sky.

- patrick lawler

question: if mice are the messengers of the dead, what messages do birds bring?

i
people usually talk about childhood as if it involves time

to me
childhood is a geography with crispy temperatures
low-hanging dark-clouded skies walks in the woods

with my tiny hand
in grandpa's big hand

ii
grandpa's finger points at various birds
some black
some brown
approaching them
my two ponytails swing
as i screech out of joy
when the birds stay
& also when they eventually fly up

iii
ten years later
mother tells me when she was my age
grandpa raped her
not once but for many years
& all of grandpa's gorgeous birds
burrowing inside my chest
instantly freeze to death:

 ge re ghi
 regheghi
 geghena
 a reghena
 a gegha
 riri

Scream I, digitally disfigured self portrait

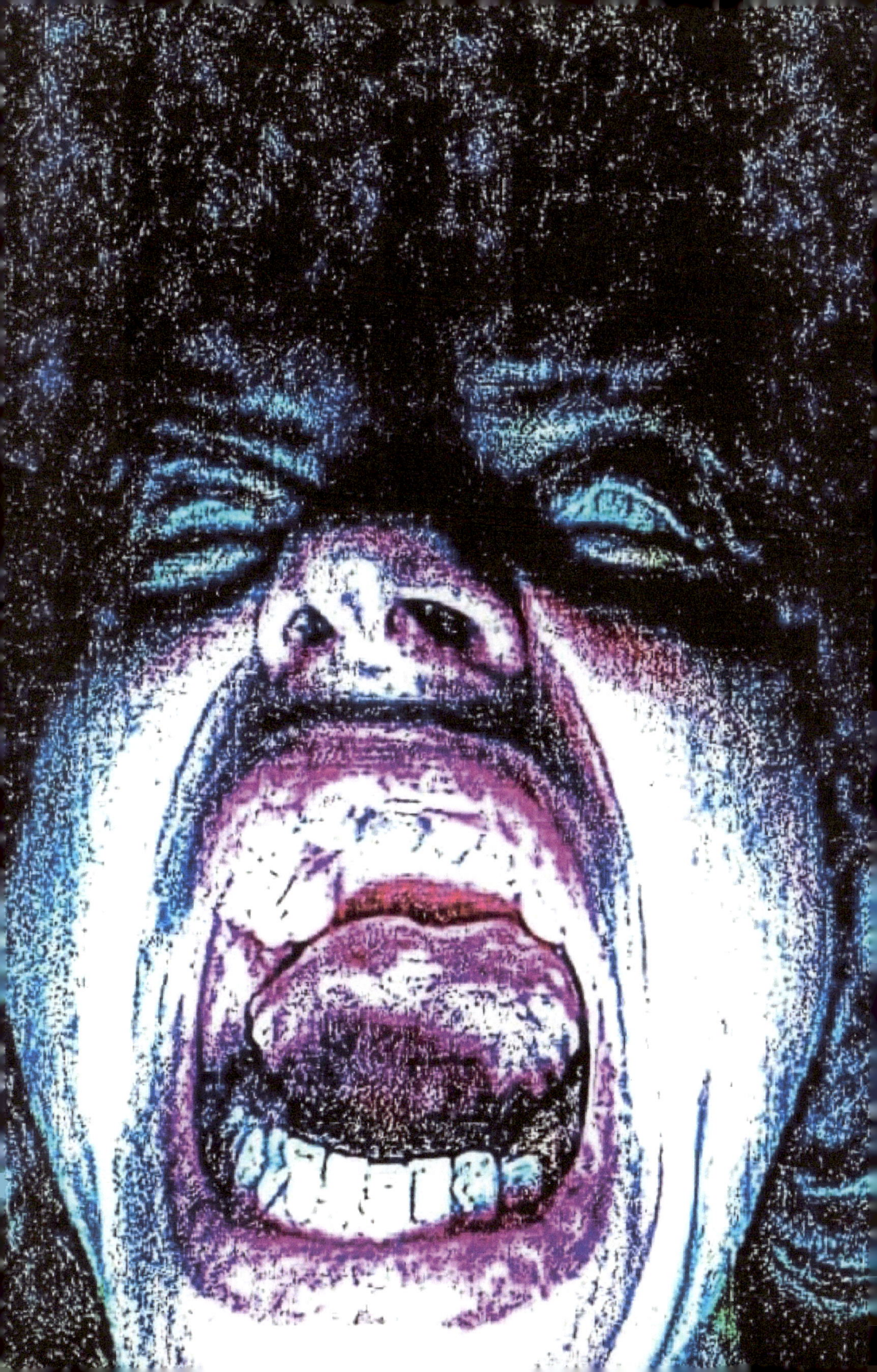

Truth-Poor

A wealthy medical doctor in Pakistan describes on Facebook how one should prepare an anus: "anal copulation can be hazardous," he comments. For the rich, anal sex, like truth, is simple: they can afford it. Yet like morality, they don't need it. Rimbaud said morality was a brain defect. The wealthy have no brain defects. As for me, the moment I speak the truth, I cease to exist. I'm truth-poor. Welcome into my brain.

Truth or dare?

My eyelids crack open. Yesterday's leftover firewood: like black butter spread over my face. Is it night? Playing with fire is an art. My muscles feel like chewing gum. There's an itch in one, possibly in both, nostrils. Where did I leave my phone?

Flashback

Picture an eight-year-old girl: what if I were a boy? Would I've become a junkie? An alcoholic? It's 1985: the naked body of Mother glows in the early morning sun, as she's on the phone lying to Daddy: they're divorcing, but he doesn't know it yet. Another man is sleeping in his bed. I can smell him. It stinks. Mother stands like an erect penis in the living room in front of the TV. I see her curves reflected on the screen. This is my first sleepless night ever. Burglars have permanently set up camp in my head.

Flashforward

He strokes my cheek. Daddy's hand smells like a mix of old piss and nicotine. The scratched-open calluses of his dark-brown hands feel like tiny needles. Daddy drops me off at school. At the school gate, his skin looks browner than when he is at home. His eyebrows. His hair. Thicker. Blacker. He gives me money for lunch. I feel guilty that I'm feeling embarrassed, but I crave to blend in with the fair-skinned kids. My skin is white as porcelain.

His cigarette-lips kiss me. I find them sexy. I want to have sex with them. I don't want to have sex with him. I want to have sex with him. Tiny hands push his face away. I feel guilty, but I need to survive. I can't afford the truth. Like him, I'm truth-poor. I run as fast as I can. Don't look back. I feel guilty. I don't feel guilty.

Flashinward

My sleeping bag is my body's extension: we are one curled up half-circle. I'm a squirrel in winter. I'm hibernating. Artists wake up early. Writers aren't artists. Poets aren't anything. Or perhaps, they're the *real* queers.

Flashback

Mother organized a birthday party for me. We are in the seventies and so is our wallpaper. Mummy looks like a girl. That's the truth she can't afford. Like me, she's truth-poor. She wears skinny church bell pants. Purple. I have no clue where Daddy is. I remember that he often farted in his sleep. Mummy sits as if paralyzed in a black armchair. Mummy's eyes are black and melancholic. Just like Daddy's. Just like mine. Just like yours.

Part II

We are in a fishermen's village. Two hours from Athens by boat. 95 Fahrenheit. The horizon is sizzling turquoise and cobalt Aegean-blue. 1986. The first thing Grandmother does is hold up an almost twenty-five-inches-long fish. Nine children have made Grandmother rather corpulent. "Look at this photo," Grandfather says. "See how beautiful your grandma once was." The black-and-white picture shows a slender young woman with pointy facial features and a Mona Lisa-smile. "But look at her now," he says. He holds his cigarette squeezed between his thumb and index finger up in the air (so typically him). His lips bent downwards with disgust: "look at her now." He nods with his chin in her direction. Grandmother's hair is black, like Daddy's. "I hate fish," I said in 1986.

Eight years later Grandma died in a car accident.
I'm constantly eating that long fish.
I'm forever digesting that eternal fish.

"You swim just like a little fish," Grandmother used to say.

Flashinward

I need to get up. Where's my phone? A memory refusing to forget me says I shoved the thing under my bed. Why? My fingertips rub over sandy stone tiles. 2016. January 14. 09.42 AM. Not bad, considering I fell asleep when birds already sang

Flashback

Mother calls me into her room. Her voice trembles. I dreamed Mother wasn't human. In my dream I peeped through the keyhole of her room. She was lying in bed. Part of her body was metallic. I glimpsed inside her. It looked like the mechanism of a 1985 clock. She turned her head in the direction of the keyhole. Her eyes met my eyes and my real-time eyelids break open. At the breakfast table, I know that Mother has become a slightly different woman. That's the truth I can't afford. Like me she's truth-poor. In Pakistan a wealthy doctor was executed. On rare occasions the truth does claim the rich. Truth or dare?

Cycladic Goddess birthing post-human baby (Acrylic on 4'2')

ground hummingbirds

>holding back tears / the sadness crusted in your eyes may crack

i was all too familiar / once / with the tears' journey / out of the stomach / up into the heart / throat / trying to pierce through the eyes / throbbing against the skull / swarms of sobbing birds quarantined inside the mouth / depressed hummingbirds fluttering their wings of water /

nuggets of melancholy about to snap from the face

when still alive / the hummingbirds birthed my winged parents / cobalt angels sequestered under my skin / forming that virus / what is its name again? / freud called it the unconscious / but plato knew it was the soul /

cloistered around the corpse

i hope i'll catch that virus one day / grow an unconscious / grow a soul / i'll then chew up the hummingbirds / grind them with my teeth / while they're singing gaelic songs / celtic tales sung in the language of the dead / their fading melodies sounding like crackling fire /

sobbing and singing under my skin

as for my fluttering parents / they'll at last spread their wings / snap out of my face / fly high-high-high up / free-free-free /

like only ground hummingbirds could ever be

Human-insect hybrid is giving birth (Acrylic on 4'2' wood panel)

I'm in my element when I am a little bit out of this world: then I'm in the real world – I'm on the beam. Because when I'm failing, I'm doing all right; when I'm slipping, I say, hey, this is interesting! It's when I'm standing upright that bothers me: I'm not doing so good; I'm stiff. As a matter of fact, I'm really slipping, most of the time, into that glimpse. I'm like a slipping glimpser.

- Willem De Kooning

of the dead i hold dear

 for bill de kooning

and you
white illegal immigrant
you were crowned king of american art
a blond penniless stowaway
craving to escape the paleness of the lowlands
 (isn't that ironic?)

you dirt-poor *rotterdammertje*

and your male body
much more disfigured
than woman i and woman ii
because it's buried *in den vreemde*

doesn't it feel as if it all never stops unfolding?
this strange dutch drama:

frozen specters of longing
trying to outfox the gray asphyxiation of the netherlands within

like van gogh
we stalked what seemed the brighter lights
and hollywood's televised images roped you in

 (how could we have known, willem?)

if only we could talk to each other,
you and i

in simple nocturnal speech
burglars of the english language as we both are
i'm certain you'd tell me
that the notion of the image
is as tragic as a democratic election

 (had we known would we have stayed in *de lage landen*?)

you must have had that premonition
back in 1926
this peek that keeps poking
inside the head

shaped as an elision

shaped
as hip-hill
as berm-breast

shaped as a mutilated madonna

and even
when this glimpse began speaking to you in tongues
sounding like miscegentated american english
with a new york accent

would you have believed that
twenty-four years after traversing the atlantic
your painting "excavation" would travel back to europe
without you

your brushes were hungry in europe of old
they had to feed on these strange american ingredients:

muscles

pin-ups

& loud calligraphies of constantly smiling teeth

 (where else is the business of smiling taken so seriously as
 in the usa?)

but you
decades later
became a proud white citizen of the new world
uncrowned dutch king of rotterdam

a filthy rich *rotterdammertje*

in spite of dementia's quest
and death's cannibalistic call
you're a superstar now
with a legacy and american estate to boot

yet your soul
 (if there is such a thing)
still yearns
i'm convinced
to return to the gorgeously gray suffocation of the netherlands

 (isn't that ironic?)

Mutilated Madonna I (Acrylic, pastel, varnish, salt & sand on 4'2' wood panel)

The sound of one short sentence can kill

1983. The year my relationship with Mother was shot. This happened in the middle of the night. Mother wasn't sleeping but sitting in the living room. She was talking on the phone with Father. Father used to work night shifts. Hiding behind the door in the hallway my eight-year-old self overheard Mother's conversation. Hearing another man snore in Father's bed forged the bullet.

1990. The relationship with Mother was shot for the second time. The words "Grandfather raped me when I was your age" dealt the deathblow. Not one but three people died that moment. I adored Grandpa. Witnessing a killing by the sound of one short sentence is tragic but also fascinating. The information locked-up in the words doesn't even have to be true. The people dwelling in the relationship die an instant death. After all, doesn't a person expire when they cease to exist in your heart?

2021. What happens to the person when the relationship dies? I've always felt more haunted by the living than by the dead. Does a relationship continue to exist as a poltergeist when it dies? Ever since the death of the relationship with Mother her specter has been appearing almost nightly in my dreams. Does the person stripped from the relationship turn into a ghost: the faceless voice in your head? It seems to me that Mother is dead but kicking. Does my apparition ever kick her back?

Mutilated Madonna II (Acrylic, pastel & varnish on 4'2' wood panel)

undertaker of the mind

nightly / the undertaker of the mind / robs me of your body / & buries you in debris

from the in-between / you grab my sleeping hand / to drag your little corpse / over dreaming cobblestones / through sordid sewers / to watch your tormented torso / fall forever into discarded scrap

in the dead of night / when your snuffed-out eyes / glare at me / one last time
skyscrapers in my head explode

 o dearest
your lifeless body / is disappearing forever / in unreasonably smiling steel

death's savage mobs / had arrived early that morning / when illness first banged on my door
moaning rhythmically its cannibalistic call

ever since / now so many years ago / the undertaker of the mind
has been burying my body / nightly / into your permeable snooze
my decomposing arms / sticking out of your dreams

a sign for you / to drag my enormous corpse / over sleeping cobblestones
a sign for you / to finally throw / my tormented torso / deep into eternal dross

Necromancer (Acrylic, varnish, sand & salt on 4'2' wood panel)

Love?

it's huge and it drills. it drills and drills and drills. i'm pierced to the bed as if i'm not part of what's happening. i'm hearing myself squeal and gasp for breath. my voice trembles. i'm panting. saliva drips from my lips. pound pound pound. in between his growls i keep on asking myself what am i?

after he cums he usually sits up with his back turned against me. he grabs a cigarette squeezes it between his lips grabs his lighter sparks it up. he sucks inhales deeply exhales a long time without looking at me. i'm glued to the matrass. should i get dressed i am frozen nailed flat against these wet sheets.

i'm feeling his sperm slowly dripping out of my groin. i know he hates that. he hates stained sheets. he carries on smoking without looking at me. our room is almost empty. is this bed the only piece of furniture? there's also a worn-out night table with only one drawer. usually he keeps his cigarettes and condoms in there. this time there were no condoms.

his finishes his smoke and glares at me. his eyes scrutinize the sheets. he's scanning for stains. during all the years we've been meeting in this dark chamber with only a bed and a weird little cupboard i've trained myself in holding up sperm.

he growls. sniffs. never talks. pants. and i knew that after the first time we'd regress back in history away from culture away from language to an era devoid of talking or thinking

i can't remember when we first came to this dark room with its strange little night table. must be many years ago. besides this little room in the outside world in the many outside worlds there are other little dark chambers millions of rooms all with an awkward night table and one miserable drawer harboring what we crave to give to our loved-ones knowing very well that we're trying hard to give something that we don't have something we can't have something that we'll never have something that we can't possibly have. dearest i have been giving you the impossible.

Disembodied nervous system (Acrylic & pastel on 4'2' wood panel)

lingual interloper

for graciela iturbide

pigeons turned inside out
sprouted upside down
from my eyes

telling me that
i'm a lingual burglar
an interloper of the english language

english has no doors
the dead pigeons say

o eurydice
where is hades' emergency exit?

now that i'm finally blind
show me
how the decomposing pigeons
of the english language
have burglarized my visions

Burglar of Language (Acrylic on 4'2' wood panel)

ouR abandoneD senilE fieldS

right through the burlap sack of the heart the grandfather is punctured by roots we touch the part of the self that stays buried in sleep while forgetfulness settles on the furniture memory slides into the tiny cup of the navel the small boy finds a chrysalis in the fields

-patricK lawleR

novembeR 2020: bold letters & smog & perhaps a few numbers too emerged at californiA's pacifiC horizon the letters danced with the numbers & the smog told comedy stories with a slant we all laughed after we laughed we also cried that same month the color red disappeared & reappeared & donalD trumP too inside an abstract painting painted crossways on dessert sand afterwards we shed a few tears

heads listened carefully in novembeR when the brain painstakingly tried speaking to the mind novembeR is the cruelest month not apriL at least in 2020 my head seemed to be telling me because it's then when wildflowers at the highest tops of the peloponnesiaN highlands hold their breath & await the results of perhaps the world's most important election

the peasant-bones of my long buried greeK ancestors in spartA however grin at whatever results their hollow eye sockets forever fixated solely on ouR abandoneD senilE fields

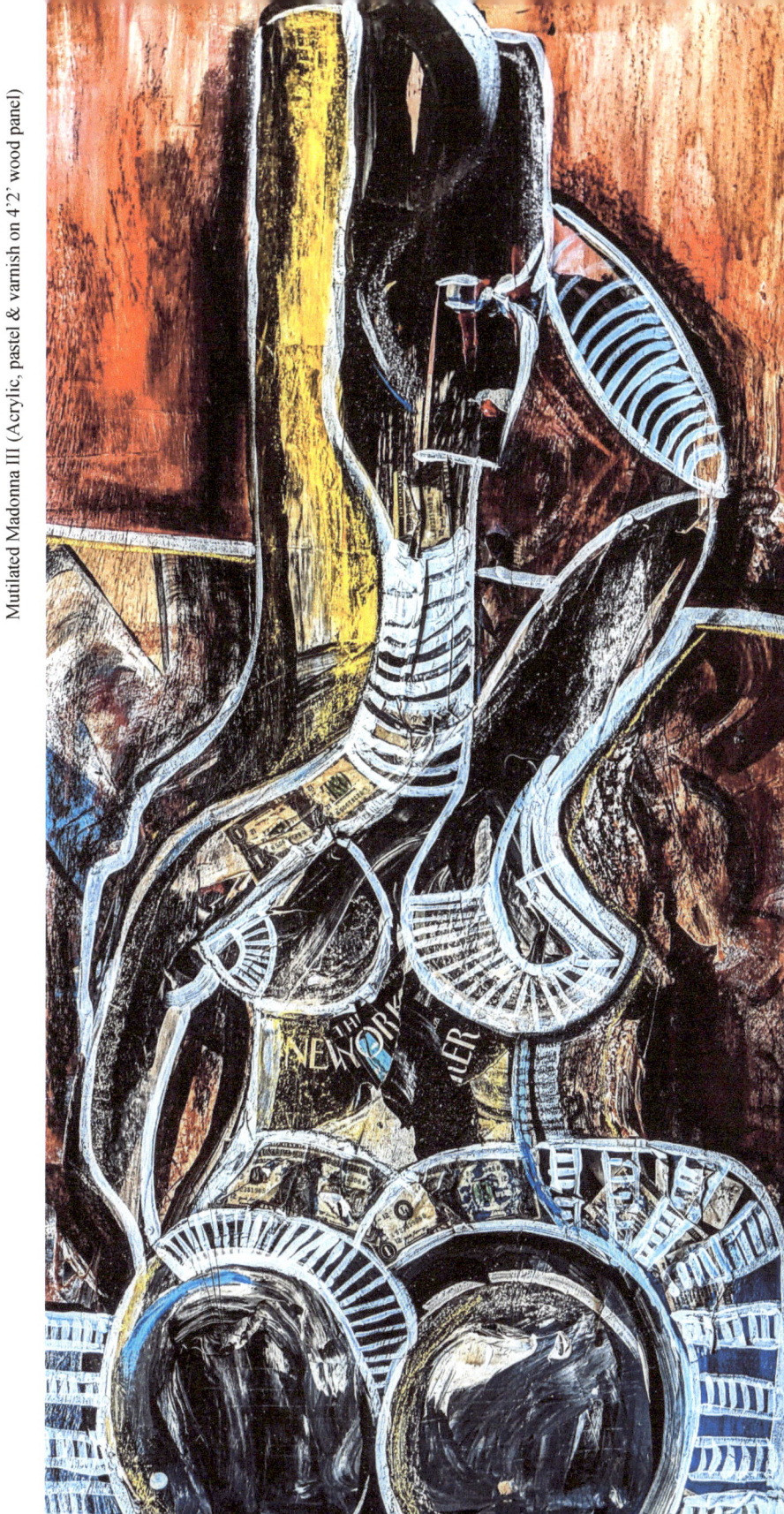

Mutilated Madonna III (Acrylic, pastel & varnish on 4'2' wood panel)

Husband became my ex-wife

2011. I shouted the relationship with Husband to death. The weight of my words broke its neck.

I was trained in two psychotherapeutic orientations. According to systems theory people usually scream louder and louder because nobody listens to them. Psychoanalysis categorizes such persons as inherently histrionic.

Husband refused to listen to me but, also, I was raised in a shouting household.
What I've learned is that people rarely listen to someone screaming and rarely scream at someone who listens.

2012. Husband's masculinity was lasered to death. Nobody sees what's behind your clothes. A beard is difficult to hide.

Beard symbolizes penis

No beard = No penis

When Husband lasered his beard away he symbolically lasered his penis away.
The few hairs sprouting from beardless Husband's chin seem sexless.

2014. Husband legally became my ex-wife. Where did the man go? Dead? Now and then it seems as if he glares through the eyes of my ex-wife. He turned into a glimpse: a glaring glimpse. Can the dead glance through the eyes of living? Where will Husband's gaze go when my ex-wife dies?

Mutilated Madonna IV (Acrylic & pastel on 4'2' wood panel)

soft typewriter of the womb

"in the soft typewriter of the womb you do not
realize the word-armor you carry"

-william s burroughs

picture them as sparkling little lice
wriggling across god's black silicone skin

 as undulating falling stars
 in an endless dark universe

i'm talking about mermaids

fluttering their fishtails
rotating their torsos in slow motion

trying to squirm to the other side

where a transvestite language
not yet born waits to be spoken

 these winged sirens
 with soft typewriters
 as wombs

 gestate sonic calligraphies

 in which androgyny
 sets beyond six writing suns

these pregnant mermaids

continue their sensual
bathing

diving in and out

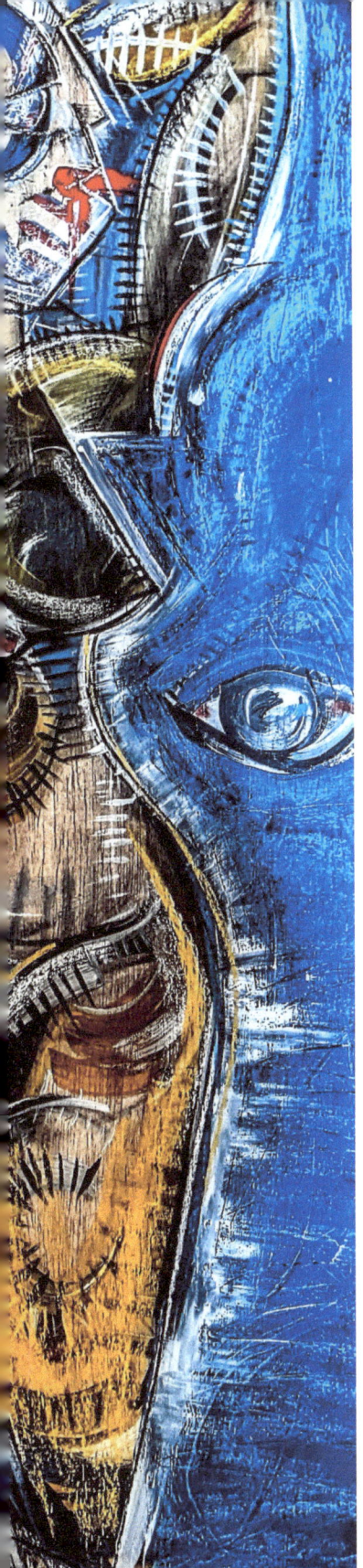

Mutilated Madonna V (Acrylic, pastel & varnish on 4'2' wood panel)

of stars planets comets

orbiting
a feverishly typing sun

 in winter

 when god hibernates
 in his favorite black hole

the mermaids
stroke the orifices
of their own mirage

fluttering their fishtails
in the sweat of their dreams

 their torsos forever rotating
 with unimaginable speed

arriving faster than light
at the other side

 of god's black silicone skin

 where words are spoken

 from a freshly born
 transvestite language

the black city

for joyce mansour
& mohsen l belasy

sad sopranos
flood through freeways of perpetually unfolding decibels

 this
 is an albino opera of high pitch voices

shrieking sirens
 chaotic choreographies
 mad mermaids

 furiously Φonetic
 ferociously Φonemic

these mermaids
enter the black city

 undulating through buildings
 chanting their mantras
 fluttering through cement
 singing through splintering walls of sound

releasing words as if fish with decibel-scales

 these words
 slide
 glide
 sneak
 peak
 into mute buildings

speechless factories recite their oceanic wailing

							words as if fish without internal organs
				whispers
					wheezes
					chuckles
					giggles
					sighs

trillions of decibel-fish
dive in and out
of black windowless walls

							orchestrating wild tornados of aquatic murmur

buildings crack
bricks belch

the black city moans

from afar
the deaf hear sounds approach

				from further away
				the blind see more sounds

groans
rattles
sighs

				& then
				the whispers disappear

sneaking into a collage of crumbling down hallways

 hiding in worn-out storage rooms

 whispers sobbing like abandoned infants

orphaned molecules dance with amputated fish

the empty fish

 sob
 groan
 moan
 like a battered woman

 sirens stroke the woman's cheeks

 there's humming everywhere

humming of fish birthing new organs
organs speak in muffled speech
only buildings understand what they're saying

 there are no trees

fish whisper
buildings crack
bricks belch

the black city moans

 blizzards of melodic high pitch sighs
 exit the black city

 Scream II (Mixed media)

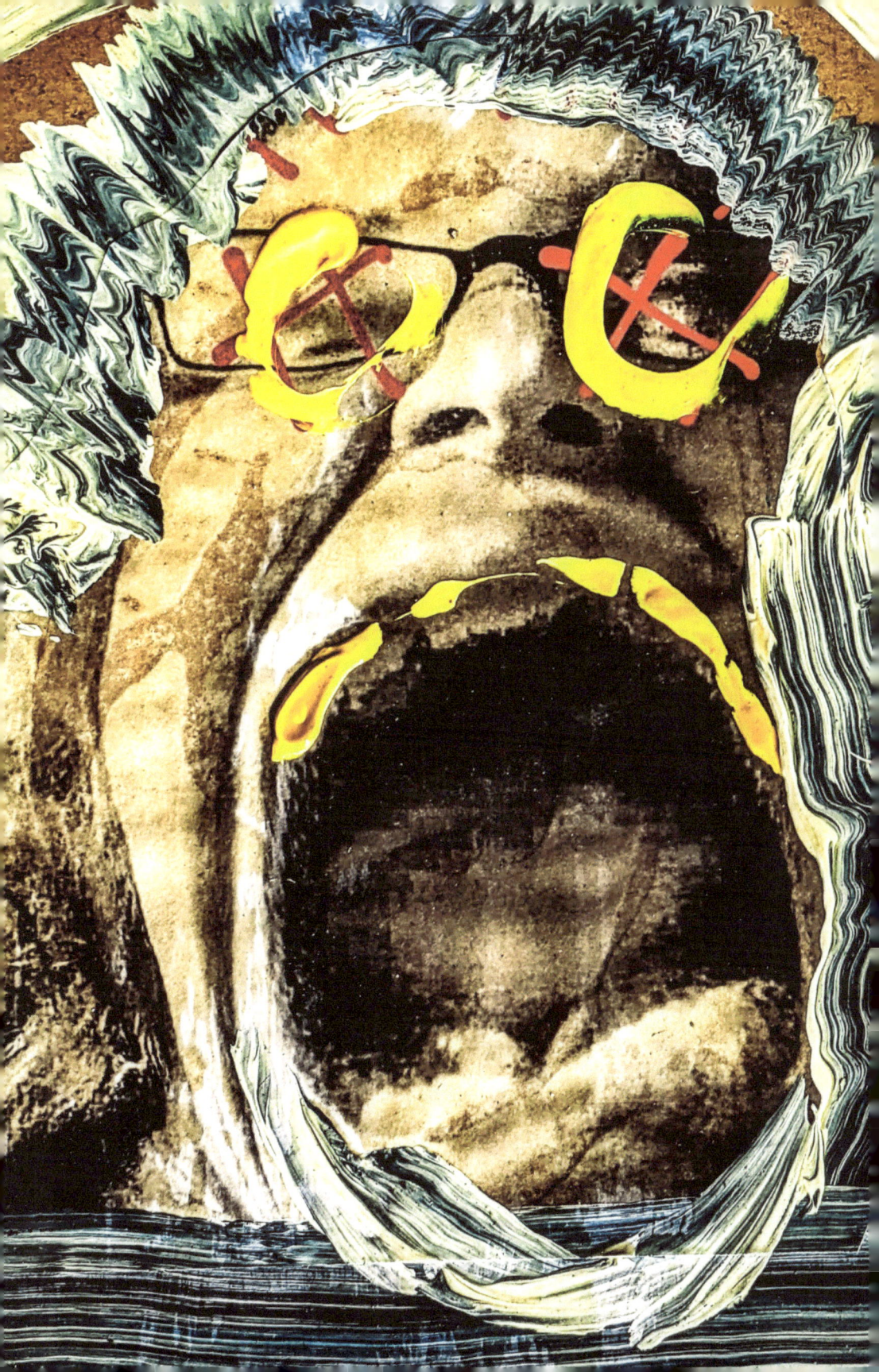

a necromancer's advice to baudelaire

exit your corpse
eat up your organs
massage your coffin

rage rage rage
rage against the fire
inside the ocean's sarcophagus

commit suicide in the desert of love
listen to the sound of the end of desire

tell us about your life as a transcendental vampire

serve your tongue with an exquisite french sauce
dance with the dead in the center of the sun

slam to punk rock music during your funeral
paint a cross with the bile of bats

swing with deceased shamans on saturn's ring
peel a smile from your face

twist and shout with necrophiliacs in a swirling vulva
rewrite the tibetan book of the dead

lure dead mermaids with the smell of zombie-genitals

pray to your oldest fetal ancestor
sacrifice stillborn eunuchs

& make love to edgar allan poe
like a beautiful dead woman
at the last zero point of eternity

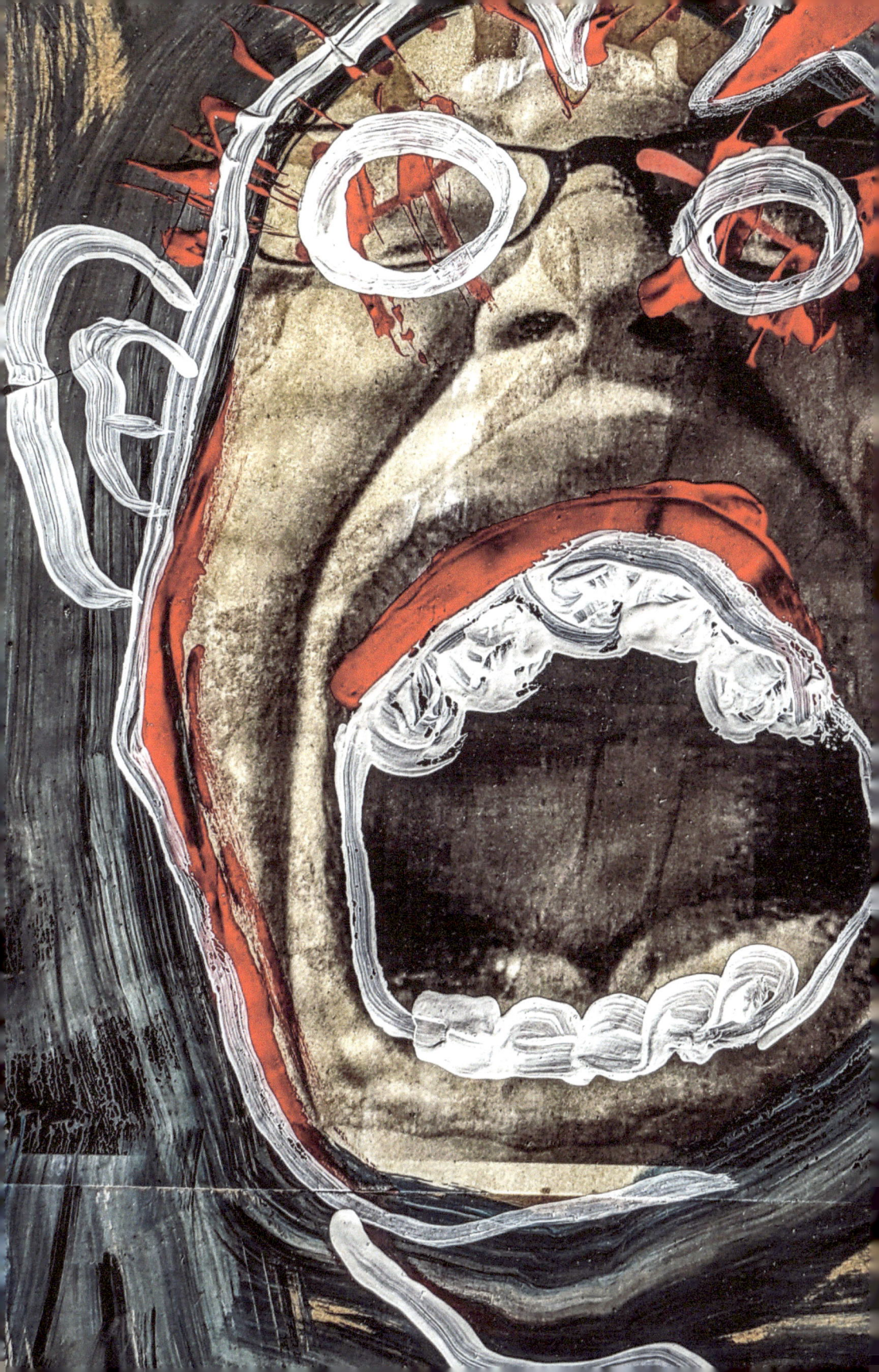

artifacts for future space travel

"man is an artifact designed for space travel. he is not designed to remain in his present biologic state any more than a tadpole is designed to remain a tadpole."
-*william s burroughs*

one lonesome octave

do
re
mi
fa
so
la
si
do

echoes across infinite black space

eight distinct sounds
synthetically conjured
at the center of all suns

i know it is you
who lives
in the middle of all of them
in the middle of all stars

you

a sonic creature
permanently escaping
from the far future

you gestate music
in your intergalactic womb

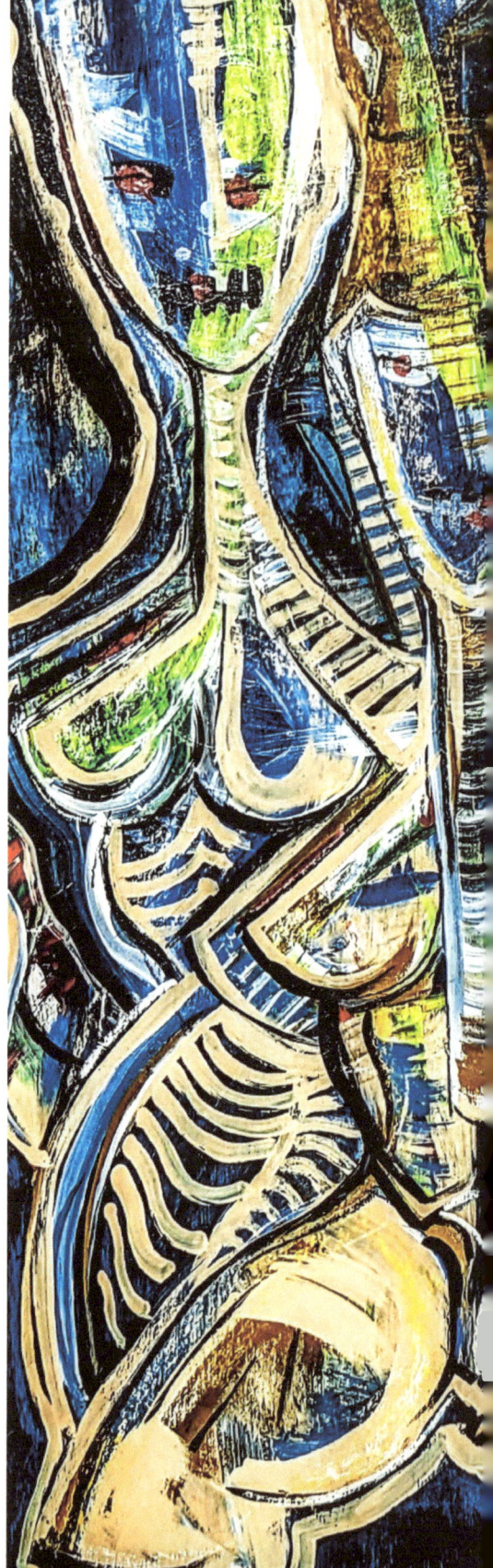

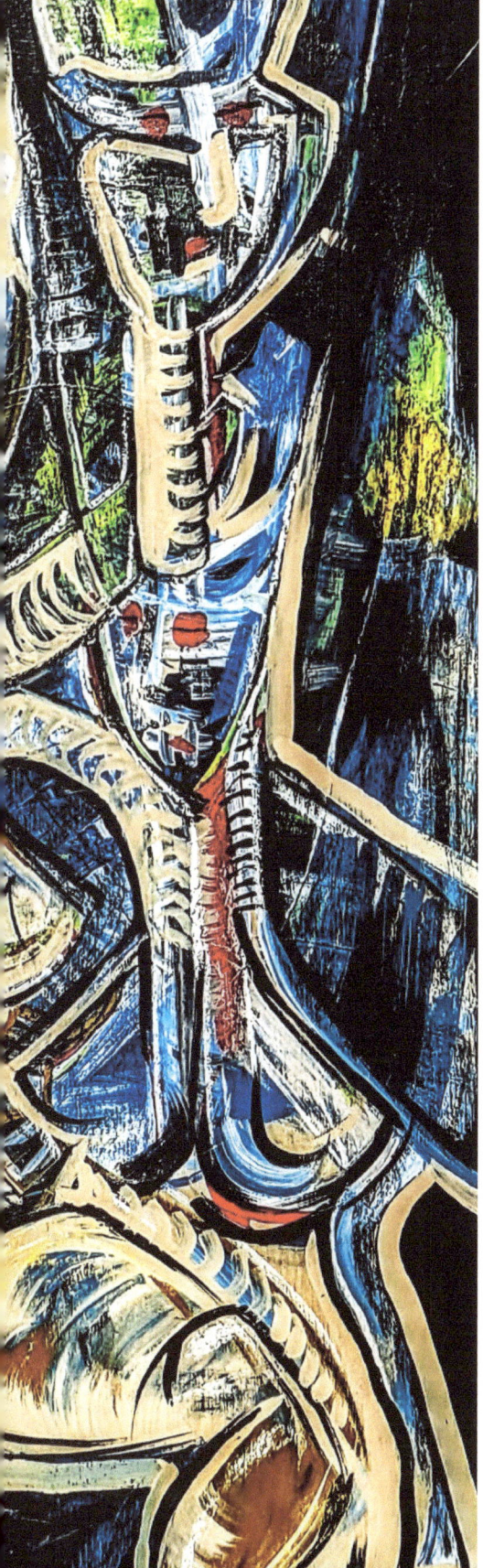

your monsoons of music
embalm mentally mute mammals

without vocal cords you sing
without ears you hear

you plant seeds of sound
in pre-human skin
to telepathically train
the human ape
for future space travel

in ten centuries
languaged animals
will travel into sound

in twenty centuries
speaking mammals
will think in alien grammar

in thirty centuries
one lonesome octave

do
re
mi
fa
so
la
si
do

will traverse
infinitely black skin

but you'll know
it is me

Battered dead women congregating (Acrylic on 4'2'
wood panel)

electroshock therapy for the climate

this was before the pandemic
before gastritis constipation heartburn strange
headaches burning joints

i still masturbated back then compulsively of course

that was the best part

this was before the 45th president
back then my stomach tolerated german beer zinfandel french champagne exquisite belgian chocolate

what a beautiful time it was

during this edenic era i loafed around dharamshala the town in india where the dalai lama lives

i stopped at a sidewalk café in mcleod ganj for a drink or two

sipping from my margarita i overheard two young men talking
their dark bristly eyebrows told me they must be from israel
dharma bums of some sort

 thoughts are like clouds
 they come and go
 one of them said

they were drinking cannabis infused *bhang lassi*
& munched on what i imagined to be gluten free falafel

waiting for my third margarita i reflected on their words
& thought to myself:

if this climatic metaphor holds up
 may we then assume
 that emotions are like rain?
 if so what would the emotional equivalent be of drought?

the dharma bums left & after four or five to be honest i don't remember how many margaritas after all we're in 2020 now this was before brain fog glucose intolerance high cholesterol borderline diabetes acid reflux gluten allergy

i still watched porn back then compulsively of course

 that was the best part

i left my café looking for chocolate belgian or swiss i didn't care as long as it was bitter & black

i headed towards the kalachakra temple the blackest & most occult of buddhist sanctuaries

a *sabziwalla* there close by sold my favorite imported pralines

probably because the month was june it so happened that on my way
i overheard two passers-by tourists perhaps
from bombay or new delhi
one had a big moustache the other was almost bald:

it's the second year that the monsoon rains
may not come at all
one of them said

a masticated chunk of chocolate was gliding down my throat
while i reflected on their words thinking to myself:

if the monsoon rains are skipping years
may we then assume that seasons can run away?

2012: endoscopy
2013: colonoscopy
2014: proton pump inhibitors
2015: one gallon of water per day
2016: federal elections
2017: gluten intolerance test
2018: lost 45 pounds
2019: spent a year at a monastery

this was during the pandemic after federal elections

doing *caca* had improved zinfandel was a thing
from the past

strange headaches had turned into normal
headaches

i had exchanged masturbation for meditation

& compulsion for compassion

 but was *this* the best part?

during this post-edenic era i found myself wearing a
mask

sitting at a sidewalk café somewhere in hollywood
sipping from my cup of licorice tea

this time i overheard a voice in my head:

now you're the dharma bum!

judging by how i smelled i think the voice was right

you know that thoughts are like clouds, right? the voice continued

reflecting on these words i looked up to the sky & thought to myself:

if this climatic metaphor holds up
& it's raining less and less
may we then assume that the sky is constipated?
the next moment more questions flooded my head:

if there's an increase of both schizophrenia &
people born in the wrong body
may we then assume that the climate is into drag?
is the climate hallucinating?
is the weather traumatized?
has the climate turned bi-polar?
are we sexually abusing the oceans?
does the weather have an existential crisis?
has the climate become sociopathic?
is drought the climatic equivalent of burnout?

haunted by these questions i ran back home as fast as i could

i had to use an enema

strangely it rained the exact moment i relieved myself

 musing over this weird coincidence i thought:

> *thoughts aren't at all like clouds*
> *they aren't like foxes either, mr hughes*
> *thoughts are like termites*
> *they run amok inside my head*
> *competing to swallow up not only each other*
> *but also my pen the hand holding the pen my words my sanity*
> *my sleep my bowels my muscles my nervous system my*
> *neurotransmitters*
> *my tongue*
> *this page*

content with having voided my head i cleaned up my enema took a shower got dressed again

back in my living room i looked outside of the window the rain had stopped

there were gorgeous cloud formations
a marvelous rainbow roofed our community

this
 was the best part

Orpheus (Acrylic on 4'2' wood panel)

the invisible men of mist

august 2021 it rained fire in los angeles so i flew up to san francisco

but still i was walking fast thinking fast feeling fast sweating fast

 still i was seeing dark apparitions

apparitions? you either see them or you don't

like san francisco's fog you either like it or you don't

my favorite part of san fran?
 the mist

is it because i don't believe in revelations?

some things have to remain concealed
my motto is
 "avoid emotional incontinency at all costs"

in san fran the mist creeps steadily sneaks into town

feeds into market
feeds into mission

 feeds into its ghosts: the homeless

fog people even more transparent than water:
 meet
 the

 invisible men of mist

i love you can't touch the fog

like transparent humans: fog is untouchable

like the dalits of india: 300 million people
the whole of the usa
not to be touched

think the fog away & what would become of san francisco?

think the dalits away & what would become of india?

it's difficult though to think away see-through people

<div align="center">***</div>

so I'm back in la
still i see dark apparitions still it rains fire but where are the
people of fire?

in la the see-through people are foglike too

fire or fog? where do i fit?

nowhere i suppose like those dark apparitions you either
see me or you don't

& even if you'd see me i love you can't touch apparitions

& even if you could touch me "avoid emotional incontinency
at all costs"

my favorite part of los angeles?
the wind

it's untouchable it touches me without touching me
it's invisible it sees me without seeing me

soon when the game's over
i'll be one with my favorite part of los angeles

σαν τη ευριδικη:
αορατη

you'll either see me
or you won't

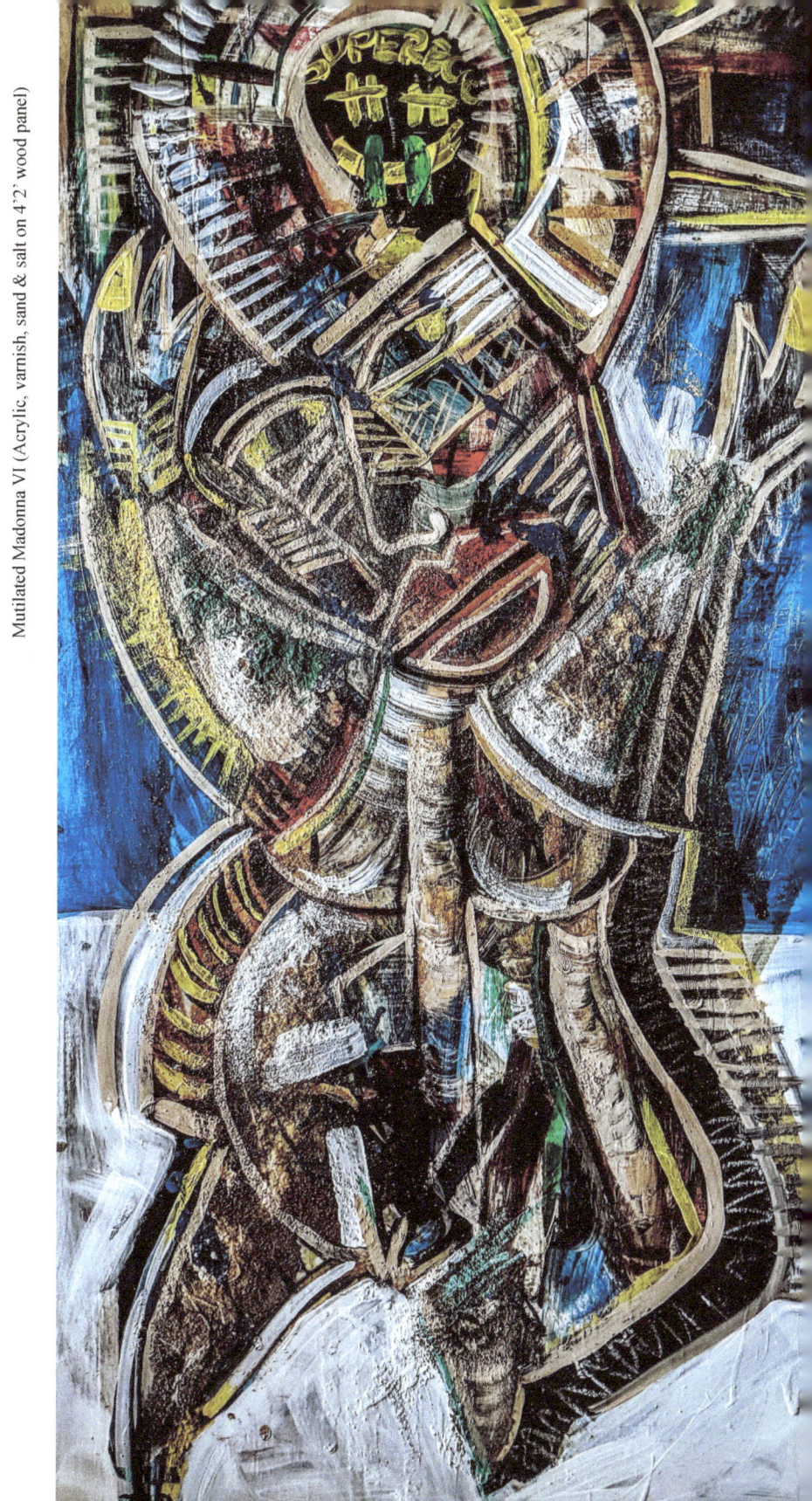

Mutilated Madonna VI (Acrylic, varnish, sand & salt on 4'2' wood panel)

Where's my lizard?

You switch on the light, and think: "some nights are inevitable."

Perhaps it's the wine. You're not sure. Maybe you're dreaming. Tripping? Do you really care? You don't know. At least right now you don't. Yet these inevitable nights also have something profound. Upon realizing this you get your usual fit of stupidity, and El *susto* (as usual) embarks on its journey of slowly encroaching upon you.

"Is this the beginning of a yet-to-be-discovered form of madness?"

You gaze at all the women's magazines lying around on your bed. You wonder: "What if the pictures would talk to me – or worse – laugh at me?"
The image of an old mad uncle pops up in your head. He claimed he knew the difference between dreaming, hallucinating and making up stories. He died in an insane asylum. Your family tried mourning him, but you've experienced firsthand that empathy isn't their strongest point.

Next, you don't really know why, but you find yourself counting all the cute little memories you've accumulated during your many travels. After you convince yourself that some or perhaps most of these memories are ridiculous, you think about your many habits, and count these. Probably it's the wine. Yes, blame the wine.

During these inevitable nights oftentimes you contemplate the many reasons why you never took pictures. Everyone is taking photos nowadays. You hate showing photos to family and friends. The idea of telling tall tales or mundane anecdotes appalls you. You glance once more at your magazines. You feel relieved. The gorgeous women crusted into photoshopped images aren't laughing at you.

"What if I forget an important habit?" is the next question you're considering. This triggers another attack of stupidity. You look at your magazines and relax. The photos are (still?) mute.

Not so long ago, when one could still go out and about, these nights seemed less inevitable. "What if the whole of who I am," you carry on reflecting, "has been built around many little habits?" It occurs to you that some of these habits might be rooted in words like "here." During inevitable nights you catch yourself fantasizing about exiting "here" and going "there," and perhaps never come back "here."

This *fort und da* from "here" to "there" annoys you. Anger wells up from somewhere in your lower abdomen. If you'd smoke you'd spark up a cigarette but you don't smoke. You quit smoking. Instead you drink. Drinking, however, is a habit you *want* to forget.

Take a look at your magazines, but don't blame yourself for not taking pictures.

Remember that you're still furious at both your absent lover and your absent spouse. "They should have taken at least one picture," you raise your voice at nobody in particular, because, after all, you are all alone. Another one of your stupidity attacks. Look at your magazines. There's nothing going on there. Or is there?

"Suppose you'd actually go mad, how would you know?"

All your mad family members start popping up in your head one by one. That scares you. You've lost count.

Wait a second. Take a deep breath, and observe your women's magazines. Anybody there laughing at you? Talking to you?

You whisper, "nobody cares." You feel angry at both your absent lover and your absent spouse. If you'd smoke, you'd light up a cigarette, but you don't smoke. You drink. You gaze at your magazines. This time you decide to look longer than usual. You stare. You try feeling if you're losing it. Nothing. Instead there's anger.

A few moments later you observe yourself looking at the space around you with greater intensity. You look at the walls, your furniture, books, pictures, magazines. You even pay attention to the insects you never bothered to relocate. You stare at the spider. It hasn't moved for months. You also stare at the little lizard that's been dwelling here with you from the time you first moved here. Glance at the magazines. Nothing, but your mouth's talking to the photos, louder and louder, until you realize you're pretty much screaming at your magazines.

You halt for a second, lower your voice and whisper, "stupid magazines, stupid uncle."
"The difference between him and me is that I have money," you tell the lizard while staring into his eyes. You think he's male. The lizard turns

his head a little, but you aren't sure. You observe him carefully. "Has he moved at all?" you ask yourself. His eyes are staring right back at you.

What are you looking at crazy lizard?

"I have money, you know," you yell at him. He undulates away and hides behind the cupboard.

Stupid lizard.

All this excitement has made you nervous. It forces you to get up. You pace around in your room, exit, walk through the drawing room, pass the living room into one of your other bedrooms and stop at the window. Nothing to see, of course, why would there be?

You giggle a little bit to yourself while thinking about the magazines. This thought makes you run, as if your life depends on it, toward the magazines, and you scream at the top of your voice:

"I'm not afraid."

"Stupid bastards," you're saying to yourself, pacing a bit more around your room.

"I know you don't give a shit."

I don't need anyone. Fuckers. Idiots. And I most definitely don't need **you**.

You pace faster and faster in the direction of the cupboard behind which the lizard hid: "I have money, stupid lizard. Aren't you listening?"

"Now you're scared, aren't you?" you yell in the gap between the wall and the closet and laugh hysterically at exactly the spot where the lizard disappeared.

You open the cupboard and see a stack of folded white shirts.

These aren't mine, you think, feeling irritated.

"Again?" you raise your voice. "Again they have put someone else's shirts in *my* cupboard?"

Fuckers. Idiots. I don't need you. I don't need anyone.

You don't know if it's because today the night is inevitably inevitable, but you decide to carefully examine the clothes. First you need to check the magazines: nothing to see there. Now go find your lizard.

"You see, I'm not crazy," you whisper into the gap in which he disappeared.

Next you remove the shirts one by one.

Who wears such ridiculous shirts?

"Idiots." Your whisper turns into a scream: "Where the hell do these shirts come from?" The decibels of your voice startle you. You become furious again at both your absent husband *and* your absent lover.

"I hate both of them, " you hear yourself say, "and the lizard as well."

Holding a shirt in your hand, you notice a tiny wet spot emerging and then another one and another one. It finally reaches your attention that you're sobbing.

"I hate them both," you whisper to yourself.
"Are these yours?" you ask.
"Tell me, sweetheart, please tell me, love, are these yours?"
More spots appear on the shirt you're holding in your hands. Your sobbing intensifies: tears running down your cheeks land on the shirt. You bury your face into what you're holding.

You look up in the direction of the spot where the lizard disappeared, and you yell, "I loved them once. I loved both of them, stupid lizard."

Your scream becomes a whisper: "I loved them both!"

A few seconds later you say to yourself: "Is tonight a dark-red night? Or is it a light-red night?"

I quit drinking, didn't I?

You pace and pace and pace, this time in all directions: out of "here" and into "there," out of the living room into another bedroom. Quick glance at the magazines.

You shout: "I'm not crazy," and you laugh and laugh and laugh.

Now you are running as fast as you can: one room into another and back into the first one.

"Idiots, I am going to teach you a lesson. How dare you? Putting your clothes in *my* cupboard. You disgust me."

At last you arrive in the kitchen. There you seem to calm down a bit. From that angle you meticulously scrutinize the drawers of the closet. After a half a minute or so, you run to the cupboard and open the drawer with one quick jerk.

"Is it because of these strange nights or because of bad wine?" You don't know, but again you wonder: "Am I dreaming or hallucinating?" You chuckle at this question, look into the drawer, grab the large knife you usually keep for these kinds of nights, run toward the magazines, jump up and you land with your knees on the bed. The magazines are right between your legs. You stab, stab, stab, till all the gorgeous women are shred to pieces.

"Now try talking to me, bitch!"

Exhausted, you light up a cigarette and pour yourself another glass of wine.

"It's late," you whisper. The essay in your magazine about nail polish can't hold your attention.

Once again I've landed in one of these strangely inevitable nights, you observe your brain think.

A little lizard is running for his life on the other side of your room.

The spider disappeared.

A large knife is resting on your night table.

You switch off the light, and think: "some nights are inevitable."

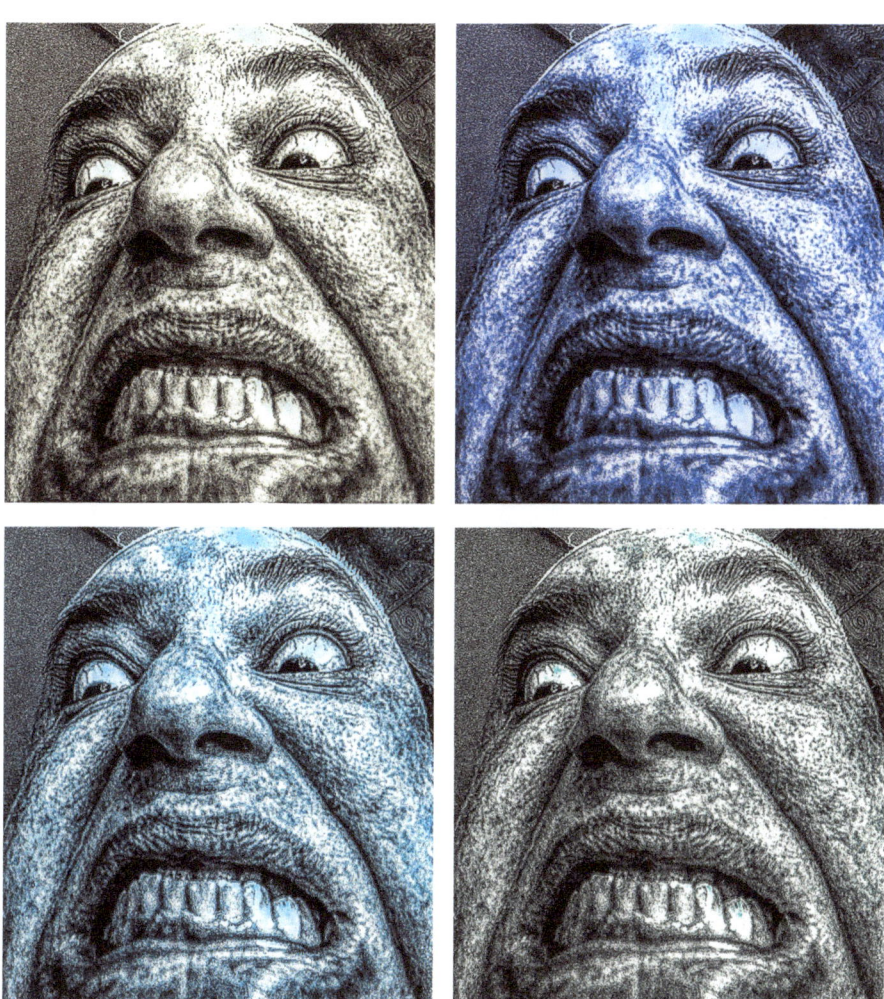

Untitled (Mixed media)

you loved me once after i died

on a bed of ice two glassy stones stare at you
your objective medical gaze drools
above my deceased sex

my naked carcass spread open
ready

your knife cuts between my cold breasts

with your thick wet tongue
you lick up moans from my dark-blue lips

with your disinfected fingernails
you excavate unfulfilled desires
trembling under my dead skin

& while you're slicing

one last memory of me
is cut in half

you loved me once after i died
when you held my kidneys in your hands

you stroked my tresses of wind
the warm caress of a senior male hand

your hot cock rubbed over my frozen cunt
& splashed!

my morbid legs wide open
your frenzy stormed inside
you sucked up my still-born agony
black blood on your face
after you came
synthetic hands sewed me up
with my soul sentenced
to an eternity in this strange steely igloo of the mind

my soul thrown before the swine of the beyond

My specter and I (Acrylic on 4'2' wood panel)

the one true body

> let them hurl a thousand curses at me
> pain finds no purchase in my heart
> i belong to shiva
> -lalleshwari (1320-1392)*

think of a mute body bursting into flames the moment it looks at you
a body like the one i drag on my shoulders

 even in sleep
 especially in sleep

at night
one particular body smiles at me

its head wears a worn-out hat

other bodies sleepwalk in my direction
bodies woven into my matrass
fondling my groin
fondling my breasts

 (copulating with the dead truly is "out of this world")

hundreds of decomposing arms
thousands of decomposing fingers

 pointing at a brick house
 at a prison
 with only windows
 with almost no walls
 with only doors

dying limps programmed
by someone else's memories
by someone else's desires
by the memories of my dead
the memories of the excommunicated
by those who were forced to speak a borrowed language

listen carefully
these bodies stand firmly behind *the body synthetic*
behind the one true body and sing

hundreds of thousands corpses march-march-marching
stomp-stomp-stomp and chant

hear hear:

the stomping of marching corpses wearing celtic crosses
stomp-stomp-stomp-stamping on my name

stamping on my body

 this is also your body
 this is also your name

we share this name
we share this body

like a word being pulled through me
like a body being pulled through me

like a body pulled through another body
like a dead body pulled through my dead body
like a poem bringing news from the edge of being
like a metaphysical phone call to lalla asking her:

lalla, you searched for your soul inside your body, but what did you find instead?

*lalleshwari, also known as lal ded, was a kashmiri
mystic of the kashmir shaivism school of hindu philosophy.
she was the creator of the style of mystic poetry called
vakhs, literally meaning "speech."

Female Dervish (Acrylic on 4'2' wood panel)

what was foreign
felt familiar
what was my own
felt unfamiliar

i left the foreign
& lost the familiar
to live among my own
as a foreigner

Αρχικά εκπαιδευμένη στην κλινική ψυχοθεραπεία και την ψυχανάλυση, η Γιωργία Παυλίδου είναι Αμερικανίδα συγγραφέας και ζωγράφος που ζει κατά διαστήματα στην Ελλάδα και τις ΗΠΑ. Έλαβε το μεταπτυχιακό της στη λογοτεχνία Ουρντού από το Πανεπιστήμιο Λάκνοου της Ινδίας και το μεταπτυχιακό της στην μυθοπλασία από το MMU Μάντσεστερ του Ηνωμένου Βασιλείου, (αν και οι συναντήσεις της με τον οραματιστή ποιητή-φιλόσοφο του Λος Άντζελες Γουίλ Αλεξάντερ είχαν πολύ μεγαλύτερη επίδραση). Η δουλειά της δημοσιεύτηκε πρόσφατα στα Caesura, Lotus-Eater, Zoetic Press, Maintant Dada Journal, Puerto del Sol και Entropy. Είναι η κύρια αγγλόφωνη συντάκτρια του λογοτεχνικού περιοδικού SULΦUR. Επιπλέον, το περιοδικό Strukturriss Magazine με έδρα την Ιρλανδία την επέλεξε ως την κύρια εικαστικό του τεύχους 3.1 Ιανουαρίου 2022 και η Trainwreck Press (trainwreckpress.com) κυκλοφόρησε το βιβλίο της "inside the black hornet's mind-tunnel" το 2021. Προτού αφοσιωθεί πλήρως στη ζωγραφική και συγγραφή, εργάστηκε ως κλινική ψυχοθεραπεύτρια για περίπου δέκα χρόνια. Μπορείτε να επικοινωνήσετε μαζί της στέλνοντας email στο giorgia.dewitte@gmail.com

Originally trained in clinical psychotherapy and psychoanalysis, Giorgia Pavlidou is an American writer and painter intermittently living in Greece and the US. She received her MA in Urdu literature from Lucknow University, India and her MFA in Fiction from MMU Manchester, UK, (though her meetings with visionary LA poet-philosopher Will Alexander have been and still are exceedingly more impactful). Her work has recently appeared in such places as Caesura, Lotus-Eater, Zoetic Press, Maintenant Dada Journal, Puerto del Sol, Entropy. Additionally, Trainwreck Press (trainwreckpress.com) launched her chapbook *inside the black hornet's mind-tunnel* **in 2021.** Ireland-based Strukturriss Magazine selected her as the featured visual artist of their January 2022 issue 3.1. She's an editor of SULΦUR online literary magazine. Before devoting herself full-time to painting and writing, she worked as a clinical psychotherapist for about ten years. She can be contacted at giorgia.dewitte@gmail.com

"'Haunted by the Living - Fed by the Dead' remains a psycholingual immersion akin to oneiric configurations that appear and evaporate as alchemical astral grammar. This writing enacts the mind sans the palpable body, sans its subsequent experience as if preparing the way for its own inevitable journey via inward transparence. Reading this work is not unlike the impalpable charting one finds in Tibetan experience active at Potala, an experience superimposing inner degradation and perturbing in the cyclopean furnace."
-Will Alexander

"Let's begin with this: "Is this the beginning of a yet-to-be discovered form of madness?" 'Haunted by the Living - Fed by the Dead,' Giorgia Pavlidou's creations of poetry and paintings ask how are we fed? How are we haunted? Ultimately what nurtures us is what obsesses and inhabits us. She welcomes us into her brain—flashbacks, flashinwards, cranial cracking, soul fracking. Sonic crash. Whiplash. This is the mirror the dead hold up to the living. Pavlidou is "orchestrating wild tornados of aquatic murmer." She is a burglar of the English language, the interloper, composing on "the soft typewriter of the womb." Pavlidou conducts her séance to get in touch with the living because unless you are intimate with death, you cannot be intensely alive. The vibrant paintings she includes in the book function as synaptic pieces of vulvic energy where the words flow through. It is as if the poems are missives delivered from otherworldly beings. Everything conflates: hallucination, poetry, story. Mix and melt. Poetry and paintings. Male and female. Prose and poetry. Eros and Thanatos. Dissection and copulation. All time comes together, and Pavlidou emerges as the "sonic creature/ permanently escaping/from the far future." These poems are extraterrestrial, transtemporal creations. Ultimately our births and our deaths merge. And let's begin with this: she 'gestate[s] music/in [her] intergalactic womb.'"

- Patrick Lawler

"This book resonates with passion for love and truth-telling. Death, travel, autobiography, soothsaying, dailiness, dream-flights, find their places here. Stylistically omnivorous, contrarian, and questioning, these poems and paintings interact with gravitas. A fierce eroticism permeates Giorgia Pavlidou's artistry and aesthetics. The conjecture is poignant.
The fact blazes. Zig-zagging words and seemingly raw paintings buoyantly represent more than one reality. What a winged book. I am in awe of this poet and artist."

Uche Nduka,
author of LIVING IN PUBLIC and FACING YOU

www.ingramcontent.com/pod-product-compliance
Lightning Source LLC
Chambersburg PA
CBHW041204180526
45172CB00006B/1186